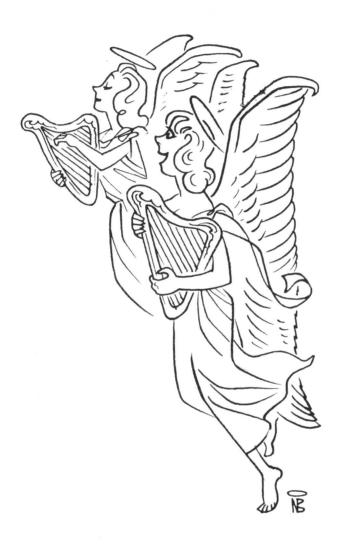

'I dare you to wave next time he comes round.'
Daily Mail, 21 Feb. 1962

NICOLAS BENTLEY

DREW THE PICTURES

Edited
with an introduction and bibliography
by Ruari McLean

SCOLAR PRESS
1990

Published by
SCOLAR PRESS
Gower Publishing Company Limited
Gower House
Croft Road
Aldershot
Hants GU11 3HR
England

Gower Publishing Company
Old Post Road
Brookfield
Vermont 05036
USA

British Library Cataloguing in Publication Data
Bentley, Nicolas, 1907-1978
 Nicolas Bentley drew the pictures.
 1. English humorous cartoons
 I. Title II. McLean, Ruari
741.5942

ISBN 0 85967 843 1

Designed and produced by Ruari McLean/Fianach Lawry.
Printed in Great Britain by W. M. Bett Ltd, Tillicoultry on Felsted Bookwove paper.
Bound by Hunter & Foulis Ltd, Edinburgh.

Credits and sources not otherwise shown:

P. ii: photograph of Nicolas Bentley by André Deutsch, late 1970s. P. iii: 'The
English Sunday', *Muddling Through*, 1936. P. v above, *Wisdom for Others*, 1950;
below, *Daily Mail* cartoon (detail), 1960. P. vii: *Daily Mail* cartoon (detail) 1960.
P. viii: *How Can You Bear To Be Human?*, 1957. P. xxi: *New Statesman Competitions*,
1946. P. xxiii: *How to be an Alien*, 1946. P. 125: *How Can You Bear To Be Human?*,
1957. P. 126: *Die? I thought I'd laugh!*, 1936. P. 129: Illustration for a poem 'The
Escalator' by Humbert Wolfe, *Sunday Referee*, 1930s. P. 130: from an advertise-
ment for Hector Powe the Tailor, 1936. P. 131: *Punch*, 1955. P. 132: *Muddling
Through*, 1936. P. 134: *How Can You Bear To Be Human?*, Penguin edition 1959.

The drawing of firemen on the outside of the book is from *Animal, Vegetable and
South Kensington*, 1940.

for ANTONIA

and ARABELLA

ACKNOWLEDGEMENTS

Since few if any libraries catalogue illustrators, unless they are mentioned on a titlepage, the search for items illustrated by Nicolas Bentley has owed a great deal to friends, strangers, booksellers and luck. Many of his cartoons have had to be credited to a book, e.g. *How Can You Bear To Be Human?*, although they probably appeared earlier in periodicals which I have not been able to trace. I also possess photo-copies of many illustrations which must have been made for books which so far have not been identified.

I am particularly grateful for continuous help and support from André Deutsch and Diana Athill, Bentley's publishing partners, and to his daughter Mrs Bella Grant; also to many of his friends, including John and Griselda Lewis, and to my friends Sue Allen, Alan Bell, Marcus Clapham, Anthony Curtis, Rupert Curtis, Jenny Dereham, Jamie Fergusson, Colin Franklin, Joan and Geoff Galwey, Alison Johnston, Faith Jaques, Herbert Jones, Ian Mackenzie-Kerr, F. H. K. Henrion, Eric Quayle, Ralph Roney, Barbara Turner, Anne and John Porter, and their daughter Catherine Porter who gave me invaluable help in Sotheby's. The devoted staff of the National Library of Scotland, and the London Library, have answered endless questions; and many booksellers have helped beyond the call of business, especially David Batterham, Bookworks, Patrick Harper, Elizabeth Spindel, Elizabeth Strong and Alan Thomas. I am also deeply grateful to my wife Antonia for help and endless patience during the gestation of the book, and to Fianach Lawry who has seen it through the press two miles down the road from her house in Dollar; also to my friend Ian Cooper the printer, for always being helpful as well as skilful.

For publishing permission in particular instances, we are grateful to *Punch*, the *Daily Mail, Private Eye,* and the *Folio Society.*

CONTENTS

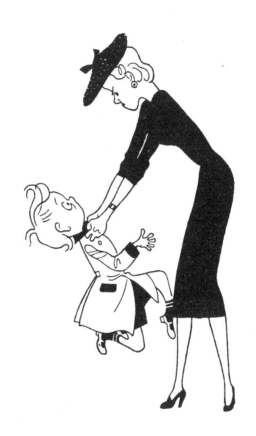

THE THIN BLACK LINE

NICOLAS BENTLEY (1907-78) was a humorous artist who ranks, I believe, with the best in the world. He drew with an exquisite purity of line, backed up by acute observation. He also wrote very well: writing and drawing were in his blood and surrounded him in his childhood.

He was brought up in London in fairly typical English middle-class surroundings by parents who were extremely untypical. His father Edmund Clerihew Bentley was a political journalist who could also draw; his father's two closest friends were Gilbert Keith Chesterton and Hilaire Belloc, who also could both draw as well as write. Chesterton became Nicolas's godfather. In his *Autobiography* G.K.C. wrote of E.C. Bentley: 'I used to say that he had the head of a professor on the body of a harlequin. It was a poetic pleasure to see him walk, a little pompously, down the street and suddenly scale a lamp-post like a monkey, with the alleged intention of lighting a cigarette, and then drop down and resume his walk with an unchanged expresion of earnestness and serenity . . . It was he who invented that severe and stately form of Free Verse which has since been known by his own second name . . . which dates from our days at school, when he sat listening to a chemical exposition, with his rather bored air and a blank sheet of blotting paper before him. On this he wrote . . .

> Sir Humphrey Davy
> Abominated gravy
> He lived in the odium
> Of having discovered sodium.'

Nicolas was also christened Clerihew, and wrote in his auto-biography *A Version of the Truth* 'The name is a Scotch one . . . The earliest Clerihew to have got himself into the record is William, of Kegge, in Aberdeenshire, who in 1644 was convicted of "profanation of the Lord's Day". As an example of the force of heredity, this tendency has persisted in Clerihews up to the present time. I have been more than once to Longchamps on a Sunday and often do things on the Sabbath that would set the Lord's Day Observance

Society, oozing the spirit of Christ, chattering with incoherent rage.' He too wrote and illustrated clerihews all his life.

Edmund Clerihew Bentley was also the author of *Trent's Last Case,* the prototype of the modern detective novel, but he never repeated that success, and, according to his son, considered himself to have been a failure.

Nicolas's mother was a Boileau, of French ancestry, whose father had been a general in the Indian army and something of an eccentric. Of him, Nicolas wrote 'of all my immediate relatives whom I never had a chance to meet, the General, who died twelve years before I was born, is the one I would most like to have known, and knowing, I feel equally sure, would have loved'. Of his parents, Nicolas wrote (in the same book) 'Emotionally speaking, I became dissociated from both of them too soon to have contracted the sentimental myopia that might have afflicted a more dutiful son. As a result, I can see them a little more objectively perhaps than if they had stayed more firmly fixed in my affections. Not that I was not fond of them, warts and all, but really no fonder than I was of some of my aunts and uncles, or of my godfather, Gilbert Chesterton. Significantly it was to him, not to my father, that I turned when I needed someone to talk to when I began to think of getting married. At other times, too, I consulted him about things it was difficult for me to discuss with my father because of our mutual reticence. Although there always existed an affectionate but unspoken regard between us, it never amounted to a feeling like the one that came to exist as time went on between Gilbert and myself.'

Nicolas was sent to University College School in Hampstead (not, be it noted, to a Public School like Eton or Winchester) and left it, no scholar, in 1924 at the age of seventeen. He was already visiting the National Gallery regularly to study the paintings, and knew that he was going to be some kind of artist. The illustrated books in his father's library pointed to illustration: he had been familiar with Caran d'Ache and Doré before he could read. So he enrolled at Heatherley's Art School, known to be good for teaching illustration. The joint principal was Iain Macnab, who became very important in Bentley's development. Bentley described him as a genius, both for the way he gave students confidence in themselves and, in particular, for how he insisted on practising observation, which became the sure foundation of Bentley's own genius. Bentley seems to have been observant from childhood, but after learning

from Macnab he wrote 'One's eye is never off duty'.

Bentley left Heatherley's after a comparatively short time, to become a clown (unpaid) in a circus. This was not so surprising as it may sound: he had always been fond of dressing up, especially with the Chestertons, who had a stage and a dressing-up chest in which he revelled — 'a huge box crammed with all sorts of finery'. And getting inside the skin of somebody else is as much the business of the illustrator as of the actor. He worked as a clown for six weeks, and then for a short time took parts as an extra in films. His experiences in the ring and on the stage are reflected in several of his early cartoons.

He then had spells in an advertising agency, in a poster artist's studio, and, very briefly, selling space for the *Daily Telegraph*, through an introduction from his father, at that time the paper's leader writer. In 1926 he sold his first drawing, to his godfather Chesterton, but we do not know what it was. In 1928 he was illustrating a diary in a trade paper, *Man and his Clothes*, his first commercial commission. Clothes interested him, and he drew them with consummate skill all his life. His early drawings for this publication are not recognizable as by Nicolas Bentley, but in the December 1929 issue they begin to be. The familiar Bentley signature was not yet evolved. This signature was in fact copied, and to a certain extent Bentley's ultimate style of drawing was also derived, from the work of an American artist, Ralph Barton, whose work he probably saw in the *New Yorker*. Barton drew for the *New Yorker* from its inception in 1925, illustrated Anita Loos' *Gentlemen Prefer Blondes*, Balzac's *Droll Stories*, and two books of his own, lived in Paris, married four times, squandered his talents, and committed suicide in 1931 at the age of forty. Bentley never met Barton; but he borrowed from him a language in which he could clothe his own ideas. Other obvious influences were Caran d'Ache, Aubrey Beardsley (especially his use of black areas), George Cruikshank, H. M. Bateman and Gustave Doré, of whom he wrote 'the grotesque and often outrageous exaggeration in some of Doré's humorous work affected the degree of exaggeration in my own'. Incidentally, Nicolas's signature, when it was finalized, involved dropping the 'h' with which he had been christened, in order that it should consist of two words each with exactly the same number of letters. A passion for tidyness was in fact a feature of his life.

While at Heatherley's, Bentley had helped to organize two

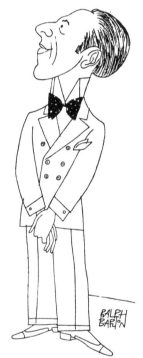

Ralph Barton, self-portrait detail from a cartoon. Note Barton's signature, copied by Bentley.

exhibitions of work by students calling themselves the 'Pandemonium Group'. At the second exhibition, Bentley recorded 'I noticed on the opening day a military looking man with a handsome and intelligent face. He seemed interested in my work and asked me to go and see him. His name, he said, was Jack Beddington: he was the director of Shell Publicity.' A year or so later, Beddington offered Bentley a job as his personal assistant in Shell's publicity department, where Bentley found himself having 'under Jack's direction, to help to co-ordinate the procedures through which the visions of his various protégés were translated into the reality of print, posters, films and other media for proclaiming the merits of Shell products over those of its competitors. Although I felt distinctly sceptical about this claim, it was not for me to bother about the ethics of advertising.' The young crew whom Beddington had collected for Shell included Edward Ardizzone, Barnett Freedman, Ted Kauffer, Rex Whistler, Arthur Elton, John Betjeman, Peter Quenell and Robert Byron. In his autobiography Bentley gives a moving account of how much he owed to his friendship with Beddington, and 'the stimulus of Jack's understanding of the creative mind, an understanding the more unusual for his being wholly uncreative himself'. And 'The three years I spent with Jack were decisive, not so much for Shell as for me. Shell might yet be the empire it is even if I had never been its minion. I, on the other hand, would certainly not be the sort of man I am if I had never felt Jack's influence.'

Bentley in fact knew that he could not remain employed in an office for ever. Rescue came from Hilaire Belloc. The first book in which Nicolas's drawings appeared had been the second collection of his father's clerihews, *More Biography*, 1929, for which he drew the jacket and eleven illustrations. Then he was asked, possibly at his father's suggestion, to illustrate Belloc's *New Cautionary Tales*. This involved a series of lunches, before one of which Belloc called for young Bentley at Shell-Mex House. 'Belloc looked round the place with disgust, then said in his stentorian voice: "If you don't get out of here pretty soon, my boy, you'll be tied to the chariot wheels of commerce for the rest of your life!" Then, while the typists ceased from typing and the clerks fell silent "You're like a flea in a Noah's Ark here", Belloc said, louder than before. "And where's it going to get you? Clear out of it while you can, my boy."'

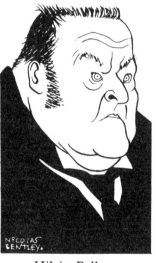

Hilaire Belloc.

After long thought and with deep regret at leaving Beddington, Bentley took Belloc's advice.

The first book of the many that Nicolas Bentley himself originated was *All Fall Down!*, 1932, with text written by others and his own hilarious illustrations. The book is dedicated to 'J.B. [Jack Beddington] from N.B.' with a poem:

> If you but knew the forest of my mind,
> There dwells therein a mocking-bird that sings
> Of days, since dead, in which I sought to find
> The meaning of unnumerable things,
> Each significant in what they call
> COMMERCE, the which I did not like at all.
>
> Though there were days that were their own reward,
> I hankered after something more expressive,
> Envious as much as overawed
> By your appearance at your most impressive.
> Now gratitude is mingled with regret,
> So please forgive my errors and forget.

The gentleman in a trilby hat on page 16 of *All Fall Down!* looks very like Beddington. The contributors, named on p. vii, include E. C. Bentley, G. K. Chesterton, J. B. Morton and other distinguished authors (including 'Baron Wooglenorm'?), but they are not allocated to pages, so some immortal lines are anonymous: for example

> 'At an eczema match
> My handicap's scratch . . .
> I scratch-as-scratch-can in the dark.'

and the poem (about Mrs Lot) 'Salt! Who goes there?' which ends

> 'Alas, for that ill-advised,
> Unhappy gal —
> Poor salicylisised
> Cerebos Sal!'

All Fall Down! is vintage early Bentley and extremely funny; but shoes, trouser-legs and faces still tend to be drawn to a formula,

rather than on observation – although even in those early days he could already achieve amazing and lurid facial expressions.

See p. 30

The Beastly Birthday Book, 1934, was the next book compiled by Bentley. It is a day-by-day anthology of literary quotations, with blank lines for inserting the birthdays of friends. The 51 full page drawings show a considerable advance in actual observation, and are the beginning of his fluency in depicting pretty or beautiful well-dressed women. A good example of this is a Bentley cartoon that appeared in *Punch* on 6 February 1935. It presents a quite ordinary joke – the man who arrives at a party mistakenly in fancy dress – but the lady hostess is lovely, and drawn with an amazing economy of line. She is also drawn with a tenderness and compassion not found in the work of any other humorous artist I can think of, including Pont. She must have been a real person, since Bentley could not help drawing portraits of faces he had observed. His first drawing for *Punch* had appeared in January 1933, and the development of his style in two years is evident.

See p. 10

See pp. 34-5

Foreigners, or the world in a nutshell, 1935, by Theodora Benson and Betty Askwith, is another step towards his final style. The line is even as a black thread, with no variation from thick to thin, and no shadows to counterfeit roundness; just accurate drawing based on meticulous observation. As characteristic as his signature was his decorative use of solid black, such as is afforded by top hats, porters' waistcoats and ecclesiastical vestments. The church, or rather its clerics, became a frequent target in his cartoons for *Men Only* when it began publication in 1935; many were reprinted later in the first collection of Bentley's work, *Die? I thought I'd laugh!,* 1936. From time to time Bentley's austere line was relieved to express textures, whether of cloth such as dinner jacket lapels or flesh such as a whisky nose. He also enjoyed exploiting the decorative possibilities of checks, tartans, lace and sprigged muslin. Dressing neatly himself, Bentley had a strong sartorial sense, both for men and women, and for all periods; he clearly loved contemporary women's evening gowns, as well as every extravagance in historic costumes. A constant theme of his work was the eternal situation of man versus his clothes, with clothes winning.

See pp. 49-51

The Time of my Life, 1937, written and illustrated by Bentley, is the story of a young man versus everything else in life as well as clothes, with everything else always winning. It is probably the funniest book Bentley ever produced; but he never wrote or drew

xiv

'Now what made me think you said fancy dress.'
Punch, 6 Feb. 1935.

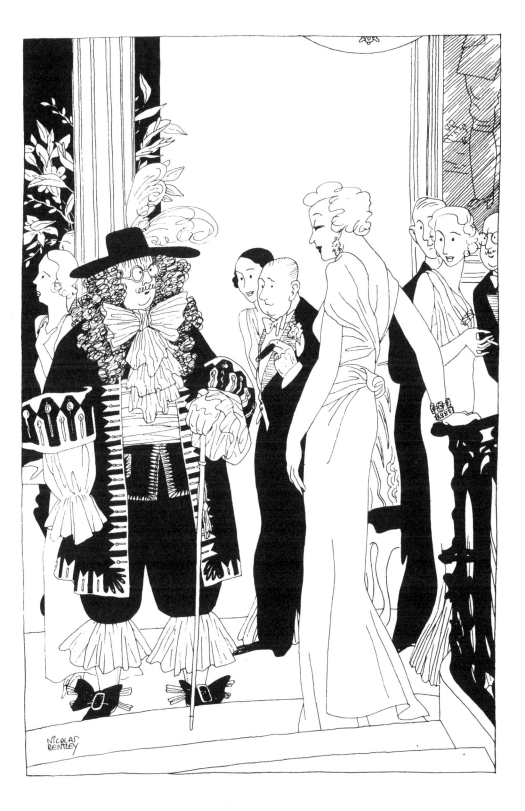

anything else in this genre. His wit, simple humour and perfected line are here seen at their best.

Bentley had married (in October 1934) Barbara Hastings, the daughter of Sir Patrick Hastings, the most famous QC of his day, with whom he became very friendly. He was himself now extremely busy as a successful free-lance artist; nevertheless he found time to become a prison visitor at Wormwood Scrubs, which he did for two evenings a week for a year. Then, in 1938, with a war clearly imminent, he joined the London Fire Brigade. His period of training, and later grim experiences in the Blitz, are vividly described in *A Version of the Truth*. Being an auxiliary fireman was a dangerous night-time job; during the day, and for the rest of the war, he served in the Ministry of Information, where he again found himself working under Jack Beddington, who asked him to succeed John Betjeman as script editor in the Films Division.

In June 1943 the Bentley's only child, Arabella, was born, which may have been why, during the war, he illustrated several books for children. He had already, in 1934, provided eight illustrations in colour for a children's book *There was a Moon*; but these plates were printed on shiny art paper from four-colour half-tones, and are among the least successful illustrations he ever made. However, in 1940 he was asked by Faber and Faber to illustrate in colour the second edition of T. S. Eliot's *Old Possum's Book of Practical Cats*. These were reproduced by photo-litho-offset and are superb, revealing that besides being a master of black-and-white Bentley also had a fine sense of colour. They are probably the illustrations best known to the public of all his work: the book has been immensely popular. During the next few years he illustrated four more children's books in colour for Faber, which are delightful, but have never been reprinted and are now hardly ever seen: *Lobby Lobster*, 1943, and *Mustapha Monkey*, 1945, both written by his wife under her maiden name of Barbara Hastings; and *Silvanus Goes to Sea*, 1943, and *In the Land of the Thinsies*, 1944, by Dorothy Ann Lovell. These were all thin landscape-format books, slight but perfect in their way, with illustrations conceived in colour, not line drawings with colour added. The only other Bentley book containing illustrations in colour that I know is *Nicolas Bentley's Tales from Shakespeare*, 1972, which have a hardness and ribaldry I find uncongenial. Also in 1944 Bentley illustrated a story for children by Eric Linklater, *The Wind on the Moon*. The drawings are in black-and-

white only: the heroines in the story are two small girls who are charmingly realized. This was, I think, the only full length actual novel that Bentley ever illustrated. He later illustrated two collections of short stories by Damon Runyon, and E. M. Delafield's *Diary of a Provincial Lady,* but delineating and developing the same characters throughout one story was not his forte. In any case, illustrators who have to make a living must draw what they are asked to draw, and publishers in England still seem to think that literature illustrated by a living artist will not sell. Bentley was never asked to illustrate Evelyn Waugh's *The Loved One,* poking fun at American attitudes to death, which would have been apt for his pencil. While I was pondering this, an explanation arrived in the post in the form of a paragraph in a bookseller's catalogue which ran 'Even though Waugh often sought out illustrators to work with, his idea of collaboration was rather one-sided. Soon after he met Stuart Boyle, the illustrator for this book [*The Loved One*], he noted: "Not used to wine or food. Potential convert to Catholicism. Clearly a hard-working, penurious draughtsman of great technical skills and little imagination. Just what I want." ' (Heywood Hill and Glenn Horowitz's catalogue of the Michael M. Thomas Collection, *Evelyn Waugh & Others,* 1989).

So the war ended. The Civil Service had noted Bentley's organizing ability and offered him a permanent post, but he turned it down. His drawing and his writing were more important. While continuing, after 1945, to draw for books, newspapers, magazines and advertisers, he had by 1953 written three thrillers, all published by Michael Joseph and later reissued as paperbacks by Penguin. The ability to write may not have been helpful to his progress as an artist. In any case, he knew that the fate of many humorous artists is to go out of fashion, and he was determined not to do that: so he went into publishing, a profession in which the name of Bentley had already been well-known: Richard Bentley had been the friend of Dickens and the publisher, under Dickens' editorship, of *Bentley's Miscellany.* In 1950 he joined the firm of André Deutsch, for whom he had illustrated George Mikes' best-seller *How to be an Alien* in 1946. He became not only Deutsch's partner but a life-long friend. Bentley's organizing ability may not have extended to money matters. Richard Ingrams, in an essay on Bentley published by the Folio Society, wrote 'He was hopeless with money, and kept several bank accounts under the impression that this would somehow save

him from disaster'. And André Deutsch's anecdote on p. xxiii indicates financial innocence. But as Diana Athill has written, in a letter to the author, 'Nicolas was a noodle in business *only* because he applied to it exactly the same concept of honesty and honour that he applied to private life. And a man whose personal finances are kept in good order, even though his income is not large and comes in fits and starts, is not really "hopeless with money".'

Working as a publisher enabled Nicolas Bentley to go on drawing without being forced to over-produce. Edward Ardizzone used to say that to maintain his own standard of living he had to produce four illustrations every day of his life. Bentley's average may not have been so much less, but he was able for most of the time to go at his own pace. He drew regular cartoons for the weekly *Time & Tide* between 1952 and 1954, and for the daily *News Chronicle* after that. Between 1958 and 1962 he drew over 600 'pocket cartoons' for the *Daily Mail,* but finally found the strain too great and resigned this commission. His cartoons were competing with Osbert Lancaster's in the *Daily Express,* and lose nothing in comparison. In wit, they are difficult to distinguish: but only Bentley could have conceived the cartoon of a pretty angel, with harp, saying to her companion in the sky 'I dare you to wave next time he comes round' (referring to Yuri Gagarin's orbit of the earth in February 1962). Bentley's economic line makes Lancaster's look clumsy; but Lancaster wins on stamina, for he drew cartoons for the *Express* from 1939 to the 70s without the slightest decline in wit or visual skill.

See p. i

Bentley had an outstanding ability to catch likenesses. His faces are hardly ever perfunctory; in his main cartoons they are real people he had observed, both rich and poor, men, women (unattractive as well as beautiful) and children, and even their dogs and cats as well. Some portraits may be called cruelly accurate, but they are never savage.

When in 1954 the monthly *Lilliput* changed to a larger format before finally expiring, Bentley was commissioned to draw a series of full-length portraits of famous people, living and dead, to accompany biographical articles. He made some 24 portraits, ranging from the cricketer W. G. Grace and King Edward VII to Diana Dors. This gift was used again when the *Sunday Telegraph* began publication in March 1964: he drew over 60 portraits for the book page until December 1971. One series, which however did not last very long, was entitled 'Bentley's Literary Lights'. The

See pp. 106-7

Literary Editor at the time, Anthony Curtis, recalls that when Elizabeth Bowen was portrayed, she wrote in to say 'I am not a literary light, nor do I look like a lesbian wart-hog'.

In 1959 Bentley published *A Choice of Ornaments*, an anthology interspersed with personal views on some of the subjects on which he had chosen extracts. This was followed in 1960 by *A Version of the Truth*, an invaluable account of his early days, but not in any sense a full autobiography. After that, he produced *Russell's Despatches from the Crimea*, 1966; *The Victorian Scene*, 1968; *The Events of that Week*, 1972, and *Inside Information*, 1974, both thrillers; *Edwardian Album*, 1974; and *The Reminiscences of Captain Gronow*, 1977, all (except the two thrillers) serious studies of events of the nineteenth century, and none of them containing his own drawings. He was also working on his monumental *Dickens Index*, to be completed after his death and published by Oxford University Press in 1988. In the same period, from 1960 to his death in 1978, there appeared at least fourteen books containing Bentley illustrations, as well as some booklets. Three of these were written as well as illustrated by himself: *Nicolas Bentley's Book of Birds*, 1965, vintage Bentley; *Golden Sovereigns*, 1970, a sort of Bentley history book, with caricatures of Princess Anne and the Prince of Wales on the back endpapers (and an ingeniously neat avoidance of having to caricature Her Majesty the Queen on the last page); and *Nicolas Bentley's Tales from Shakespeare*, 1972, with illustrations in colour as well as in black-and-white.

It is an indication of his youthfulness that when he was 64 Bentley began drawing for *Private Eye*, that most youthful of our adult satirical weeklies. He illustrated Auberon Waugh's 'Diary' and continued to produce witty and sometimes almost cruel drawings, matching Waugh's text, until he was nearly 70. His cartoon of the Royal Family sitting for a group photograph is stunning. *See p.* 104

The best collection of Bentley's drawings is in *How Can You Bear To Be Human?*, published by Deutsch in 1957. Besides cartoons from books and periodicals, it contains miscellaneous drawings and sketches, many hitherto unpublished, and endpapers which are in themselves a Bentley anthology. Bentley's reputation as an artist can stand on this single book.

The source of Bentley's inspiration is Man himself: Man, Proud Man, especially — but not exclusively — when dressed in a little brief authority. He never goes very deep, neither does the mirror.

He shows the gentler, more pleasant face of life, even the pleasant face of vice. His dukes, his middle classes, his artisans, his teddy boys, layabouts and convicts are all equally convincing. He pioneered in one field, being the first artist in England of recent times (therefore discounting Gillray) to get away with loud laughter at certain aspects of death and the Church. He was attracted to these themes not only from natural irreverence but because they gave him an opportunity to use pleasing solid areas of black. As Malcolm Muggeridge points out in his Introduction to *How Can You Bear To Be Human?* 'to the truly religious, laughter, however directed, is always blessed'. Nuns, as well as priests, are a frequent target, but always lovingly. It often seems that his women are even better observed than his men. His pretty girls, whether vacuous or intelligent, are enchanting, and his housewives, chars, couturiers, schoolgirls, Wren officers, 'cellists and hockey girls are never mere caricatures, they are honest portraits of individuals we all know. The people of England in the mid-twentieth century live on in all his pages.

His way of working (as he once explained to me in 1953, amplifying an account he wrote for the *Saturday Book* in 1945) was that he planned a drawing first in rough pencil outline; he then made more careful studies, also in pencil, of the main characters. He then cut these figures and moved the slips of paper around to find the best composition; and then stuck them down. He then transferred the entire drawing by tracing onto better paper and inked it in. In that labour lay one of the ingredients that turn ordinary drawings into distinguished drawings.

Bentley had diverse gifts and limitations. As a man, all who knew him have noted his concern for people and his readiness to give help if he could. The time he gave to prison visiting was one example; another was when a well-known writer was blackballed at the Garrick Club for writing an article criticising lawyers at a time when the Garrick's committee was controlled by leading lawyers; Bentley led a successful opposition against them. There was also his work to get the humble Fred Bason's diaries into profitable publication. That concern was never far from the surface in his art. And it is as an artist, not as a writer, that Bentley claims the attention of posterity.

Nicolas Bentley could never have drawn Fagin as hauntingly as Cruikshank did, and if he had drawn Bill Sykes, the murderer, he

would probably have made us sympathise with him. The savagery
of Searle, Steadman and others was not Bentley's way. He was not
political, not a reformer, not — at least in his drawing — a hater.
He had seen the seamy, criminal and dangerous sides of life, he was
not innocent or ignorant of suffering and death, but drew gently
with the purpose of amusing — yet with devastating accuracy and
sensitivity. Not many artists have done that. He can take his place
without apology among the greatest of England's graphic artists.

Carsaig, Isle of Mull RUARI MCLEAN
January 1989

THE HAWK'S EYE

NICK BENTLEY was a rich man: rich in ancestry, rich in talents and vocations; and rich — very rich — in friends.

Among his many activities, publishing came rather late. We met at the beginning of 1946 when my friend George Mikes wrote an absurdly short manuscript of just about 10,000 words called *How to be an Alien,* which he wanted me to publish. I said I would, provided I could find an illustrator with a big name who would be willing to collaborate. That is how I met Nick. To begin with he was rather suspicious — I think I was the first Hungarian he had come across — and wanted to sell me his drawings outright for £150, I suppose on the principle that a cheque in the hand would at least be a cheque in the hand. It took me some time to persuade him that the £150 should be an advance, not an outright fee. In the end he relented and accepted it as such. His ultimate earnings from those illustrations were quite considerable, and he always kidded me that our friendship was based on that financial deal.

In the late summer of 1950 Nick was abroad on holiday. He wrote to me saying he would not mind joining me if I were to start again, after my departure from Allan Wingate. The amazing thing was that on about the same day I wrote to him, making the same proposition. So he became one of the three arrows in our colophon, and took on a full-time office job. He enjoyed it enormously and taught us a great deal.

Nick was a perfectionist with a hawk's eye for detail and an almost belligerently protective feeling towards the English language. The first did us a lot of good as far as the physical appearance of our books was concerned, and the second raised our editorial standards. Few of our early authors got by without being tidied up by Nick, but no one could resent such courteous and intelligent tidying.

When he made a trip to the United States for us he was worried, seeing it as an occasion for the kind of wheeling and dealing which he did not think himself good at. He was almost apologetic when he came back with *The Desperate Hours* by Joseph Hayes, which was one of our first major bestsellers.

He was right, however, in not considering himself much of a

businessman. I remember when I went on a short holiday in the firm's second year, leaving Nick and Diana Athill in charge, and came back to discover that Nick had paid every bill the day the invoice arrived. When I told him that usually we waited for the statement and then took thirty, sixty or ninety days' credit, he could not see the point. 'You have to pay sooner or later,' he said, 'so you might as well pay when the invoice arrives.' I never convinced him that this was not the way the Rockefellers and Rothschilds got rich; but he, just by being himself, easily convinced me that in the conduct of a private life, that kind of simple and direct uprightness is a beautiful thing.

He was a wonderful, loyal friend; quite a stern critic at times, in a way which did a lot, I am sure, to civilise me, but absolutely reliable in his affection, and the most delightful company, interested in everything and very funny indeed.

Even after he moved to Somerset, he remained closely involved with the firm: read and edited, criticised and queried. And of course I personally still saw a good deal of him. He died in 1978, a long time ago, yet even now I feel the need to talk to him.

March 1990 ANDRE DEUTSCH

THE WRITER'S HAT

IT IS A JOY to have a comprehensive collection of Nicolas Bentley's drawings. I knew him only after 1950, when he began working as a publisher with André Deutsch and me, and in those days he used to say that he had had enough of 'drawing the pictures' (although he still drew them, of course); so I tended to think of him under his writer's hat and as the person I saw daily being scrupulously careful about the written word and unlike a businessman about money. (To Nick the line between normal business practices and dishonesty sometimes looked smudged, which brought him a good deal of affectionate teasing from colleagues.) To have him memorialized like this brings him back into perspective.

Not that one ever wholly forgot his real work: witness my hearing his voice even now, whenever I look at a drawing. He once saw me trying to draw something. 'Leave out the shading,' he said. 'Try to get the outline so true that it suggests the volumes. It's very good practice to do without shading.' I love that modest description – 'very good practice' – of his own highly sophisticated technique, and have been almost morbidly sensitive to evidence of lack of such practice ever since.

To rely solely on a line described by Ruari McLean as being 'as even as a black thread' is an austerely unemotional way of drawing, and Nick *was* austere in his reluctance to show emotion. His friends knew that he felt it, sometimes violently, but he seemed almost a caricature Englishman in his dislike of its untidy expression. It was sometimes thought surprising that he had ever done anything so wild as working in a circus, but when I saw him at a Chelsea Arts Ball in his lovingly preserved clown's outfit, giving us little flashes of his act which captured with delightful precision both a clown's ribaldry and a clown's sadness, I saw why that strictly formal technique for breaking out had appealed to him. It can go a long way into anarchy, but its rules forbid it ever to break the thread connecting it with *play*.

Style is not a surface matter: Nick's respect for form and for precision was ingrained, explaining his beautiful manners and his sense of honour as well as his clothes, which were soberly elegant with here and there a neat touch of frivolity, and the charm of his

house. Barbara Bentley was off-hand about appearances, so it was Nick who chose the colours, fabrics, furniture, doorknobs, shelf brackets, stair rods, light switches An unsuitable or unsightly detail was abhorrent to him — although his taste was too good to be rigid, and it was not a forbiddingly perfect house. Indeed, it was a bit cluttered — which added to its attractiveness because there was always a hitherto unnoticed treat lurking in the crowd of objects. Nick was, by the way, an early rediscoverer of something which is taken for granted now: the charm of Victoriana.

He was as punctilious about words as he was about things, and edited a manuscript with minute care. Disrespect for syntax irritated him as much as bad drawing. Writers with a more impressionistic approach to language used sometimes to squawk when they saw how thickly their pages were studded with corrections in his exquisite italic hand (he was one of the great practitioners of italic script, which he said he learned only because his natural writing was an illegible scrawl). Their wrong-headedness if they persisted in wanting — say — to split an infinitive would make him so cross that often, for the sake of peace, I inserted a furtive 'stet' without telling him.

Although he was obviously a well-read man I would not have known the breadth of his appreciation if he had not written *A Version of the Truth*. And the same was true of his love of music — it was not for show. The other day, reading of how Berlioz despised the work of Rossini, I suddenly remembered how much Nick loved them both, and thought how characteristic that was. His enjoyment of neat, accomplished, witty Rossini would surprise no one — but the passionately romantic Berlioz spoke to him equally clearly: a signal from the hidden Nick.

He was, of course, an amusing companion, though quietly so: the comedy was in the nature of his perceptions rather than in verbal wit. But what I remember about him even more clearly is a sense of balance and calm — an unemphatic kind of inner authority. It took recent brooding on his drawings to focus that impression. It was, I now think, the authority of the born craftsman — of the man who is accustomed (without becoming complacent) to doing what he does superlatively well.

November 1989 DIANA ATHILL

NOTE

Besides being a busy commercial artist, Nicolas Bentley during his working life was a prison Visitor, wartime London fireman, civil servant, freelance editor and reader for several publishers, partner in the publishing firm of André Deutsch, author or editor of at least 16 books in addition to the large number containing his own drawings, writer of many miscellaneous articles and forewords to other people's books, Fellow and active committee member of the Society of Industrial Artists, and popular member of the Garrick Club. Yet as an artist he was prolific, and everything he drew for publication was done to his own meticulous standards, never careless or sloppy.

The present selection of his drawings is intended to show his best work in the fields in which he specialized, i.e. general cartoons, pocket cartoons in national newspapers (which had to be topical), book and magazine illustrations, portraiture and advertising drawings. For every drawing chosen, dozens were regretfully discarded. Comments have been added to certain cartoons with a topical point which might no longer be obvious.

As most of the reproductions have themselves been made from reproductions, it has not been possible to give the original sizes. Bentley's drawings in magazines were often heavily reduced: they appear here where possible in a larger size than previously, but mostly in the published size. A few are reduced.

Dates given are of the earliest known publication, except in the few cases where Bentley's signature also carries the year.

R.McL.

Cover illustration for *Man and his Clothes*, May 1927, Bentley's first commercial job.

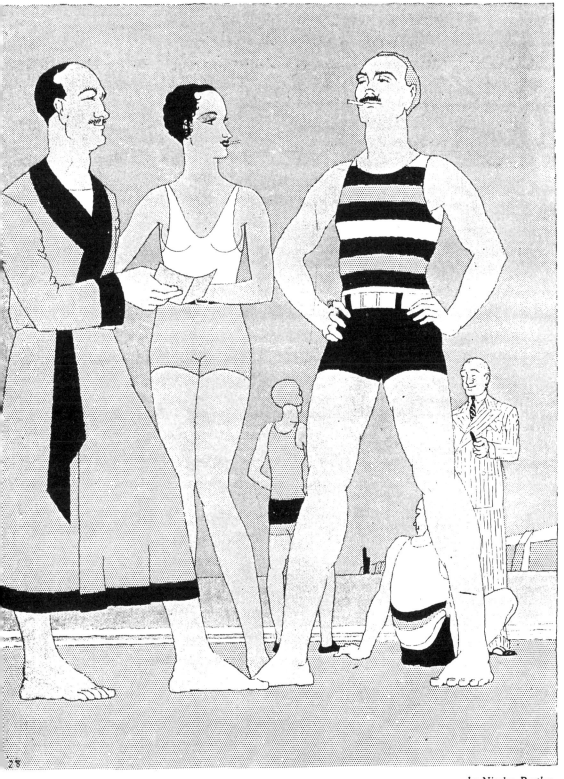

Sartor Maris

by Nicolas Bentley

Edgar Allan Poe
Was passionately fond of roe.
He always liked to chew some
When writing anything gruesome.

More Biography, 1929, by E. C. Bentley.
An extremely skilful drawing, but not yet in
N.B.'s own style.

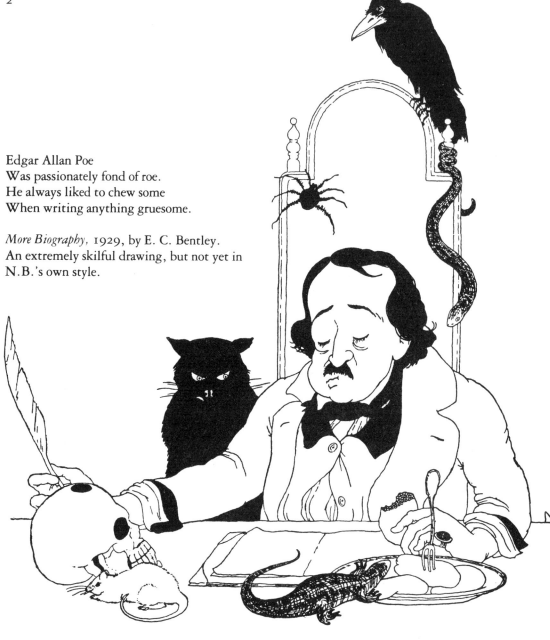

Two illustrations from Belloc's
New Cautionary Tales, 1930,
the first book entirely
illustrated by Bentley.

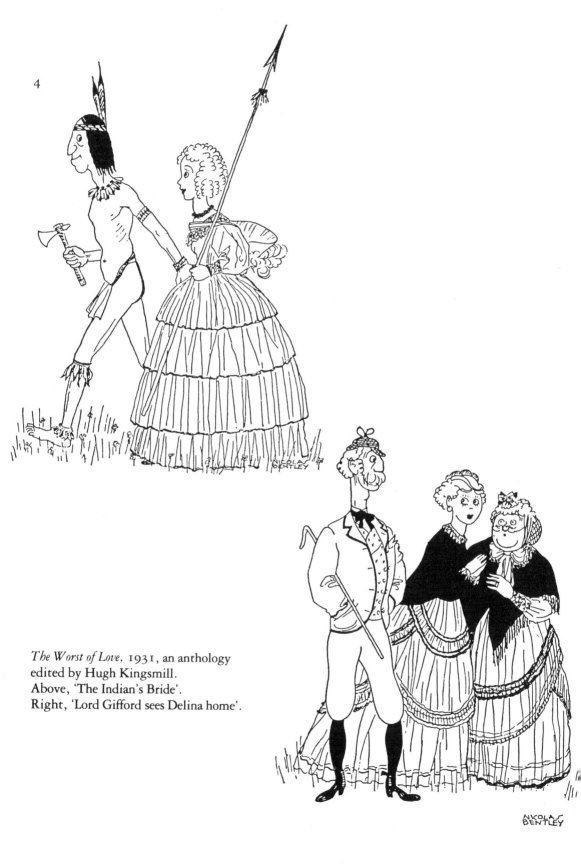

4

The Worst of Love, 1931, an anthology
edited by Hugh Kingsmill.
Above, 'The Indian's Bride'.
Right, 'Lord Gifford sees Delina home'.

'The Poor arrived in Fords,
Whose features they resembled,
They laughed to see so many Lords
And Ladies all assembled.'

Ladies and Gentlemen, 1932, by Belloc.

'We've had quite enough
 Of this horrible stuff
And we don't want to hear any more.'

Ladies and Gentlemen, 1932.

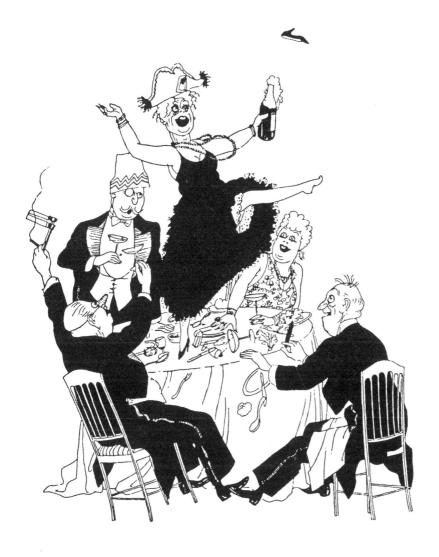

'But drank as hard as she was able
And sang and danced upon the table.'

Ladies and Gentlemen, 1932.

And Cecily

who murdered cook

1933 and still going wrong! 1932.

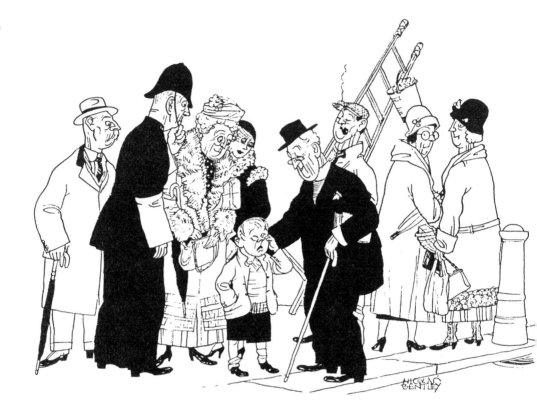

'Now, Sonny, I wouldn't cry that way.'
'Cry as you blooming well please — this is my way!'

Bentley's first drawing in *Punch*, 4 Jan., 1933.

Well, I'll thank you and Mr Blake to stay out of my dressing-room in future, see?'

The Bystander, 17 May, 1935. An echo of Bentley's circus days.

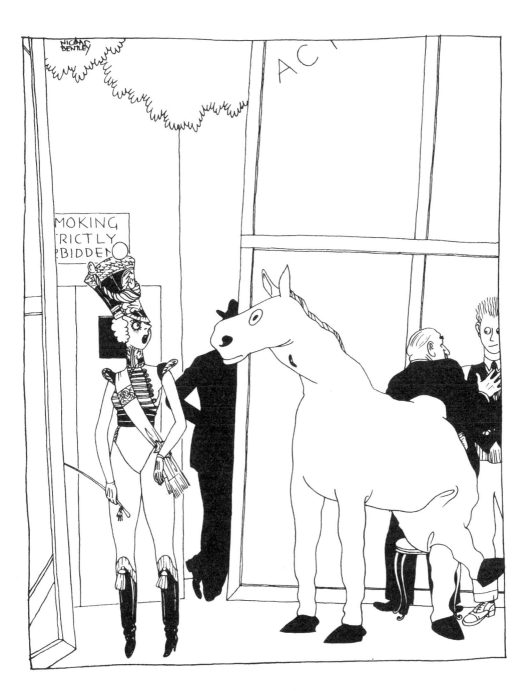

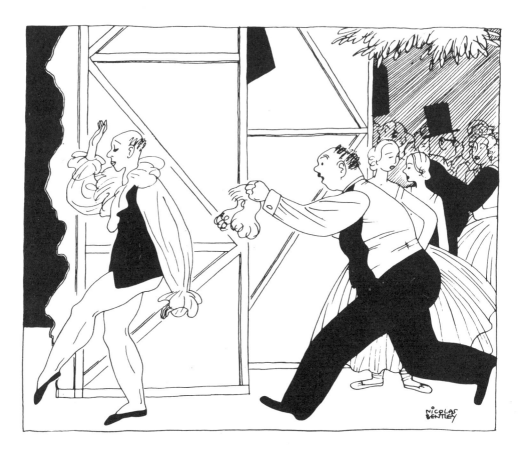

'Hey, Monsieur Stanislas, you forgot something!'

The Bystander, 22 Jan., 1935.

'. . . and this little pig stayed at home!'

The Bystander, 11 May, 1936. One of the earliest
of Bentley's pretty girls.

'Hey! Just a minute. I'm kneeling on something.' The Bystander, 22 March, 1933.

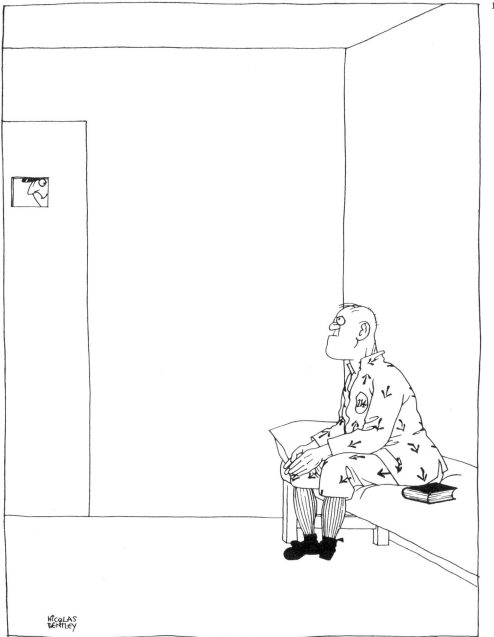

'Peep-bo!'

The Bystander, 26 July, 1933. Most humorous drawing in England
at this time was heavily shaded and cross-hatched.

'*Pianissimo yourself!*'
The Bystander, 9 August, 1933.

'Hullo — tumbled over?'
The Bystander, 6 Dec., 1933.

'Going down?'
Die? I thought I'd laugh!, 1936.

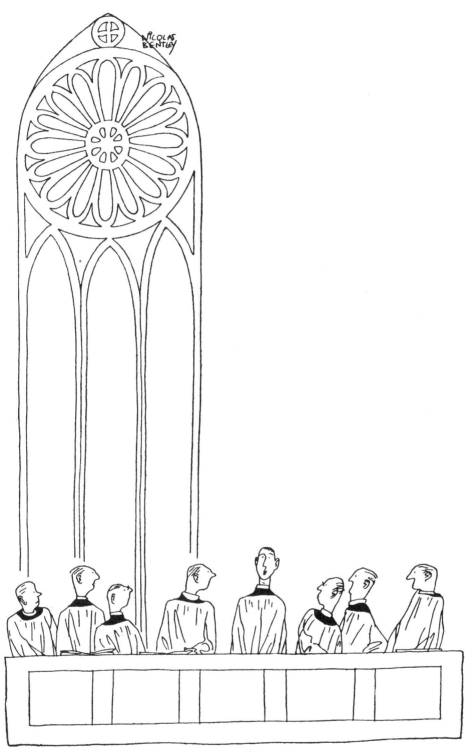

With a hey-nonny-nonny and a hot-ch-cha!'
Sunday Referee, 1930s.

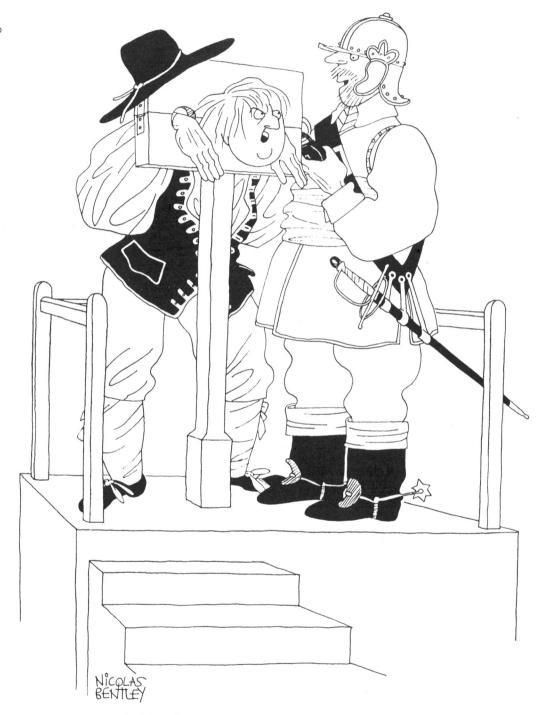

As Titus Oates said: 'You give me a pain in the neck.'
Historical Wisecracks no. 8, *The Bystander*, 27 Feb., 1934.

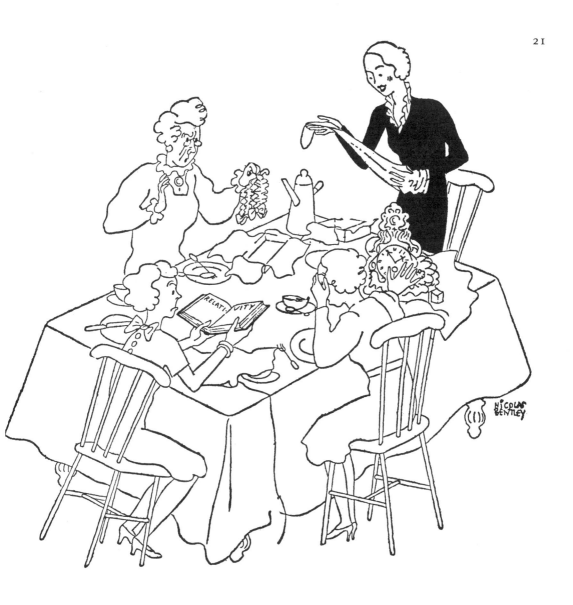

'She got what they all wanted!'
Advertisement for Aristoc silk stockings, 1933.

Mr Can't: *'The trouble is, I take too many colds!'*

Mr Can: *'The trouble is, you take too little* **Eno***!'*

Advertisement for Eno's Fruit Salt, 1930s.

Mrs Can't: 'I seem to put on fat every day'

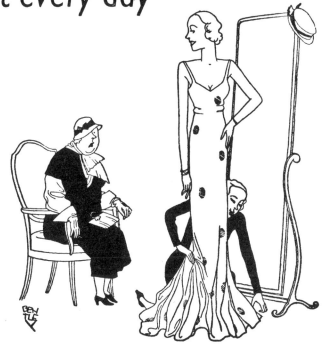

Mrs Can: 'That's because you put off taking **Eno** every day'

Advertisement for Eno's Fruit Salt, 1930s.

Mr Can't: *'What I suffer from is lack of energy'*

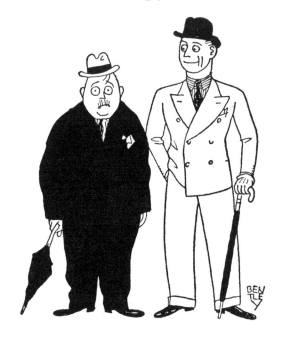

Mr Can : *'What you suffer from is lack of **Eno**!'*

Advertisement for Eno's Fruit Salt, 1938.

Miss Can't: 'The change always upsets me at first'

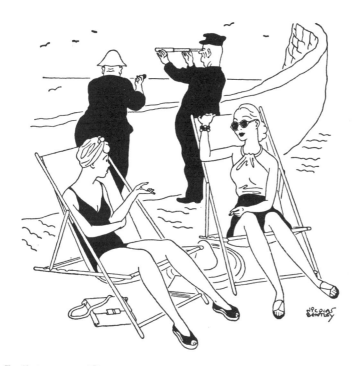

Miss Can: 'Then why don't you take **Eno**–for a change'

Advertisement for Eno's Fruit Salt, 1938.

Four illustrations in the 'Pow-Wow'
series of advertisements for
Hector Powe the Tailor, 1930s.

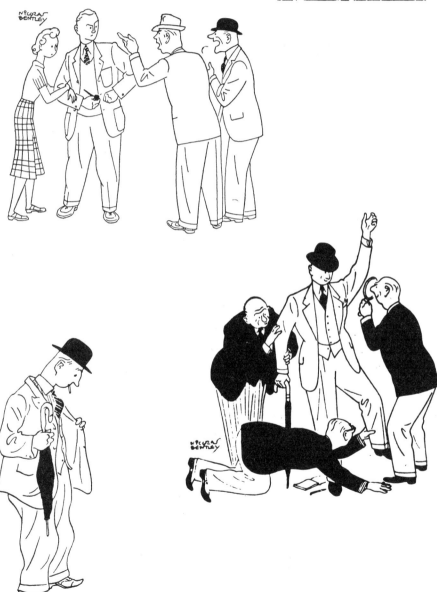

Two illustrations for 'Punch' cigar
advertisements, 1930s.

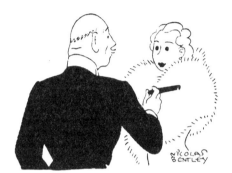

An illustration
for Davis the
Dyers, 1930s.

"Madame is not at home"

"I remain, your obedient servant"

"It made my hair stand on end"

"With pleasure, sir"

The 'Some phrases seldom ring true . . .
but You Can Be Sure of Shell'
series of petrol advertisements,
1938.

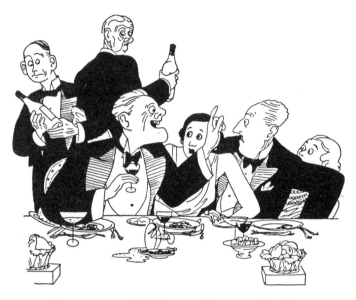

'*A young man with dark, protruding eyes, and staring,
doggy nostrils; very eager, lively and loud.*'

ALDOUS HUXLEY

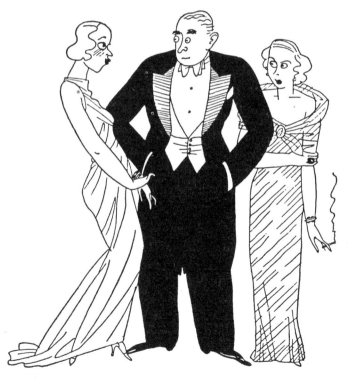

Two drawings for
Bentley's anthology
*The Beastly Birthday
Book*, 1934. His
staggering ability to
catch characters and
individuals is
beginning to show.

'*All giggle, blush, half pertness and half pout.*'

LORD BYRON

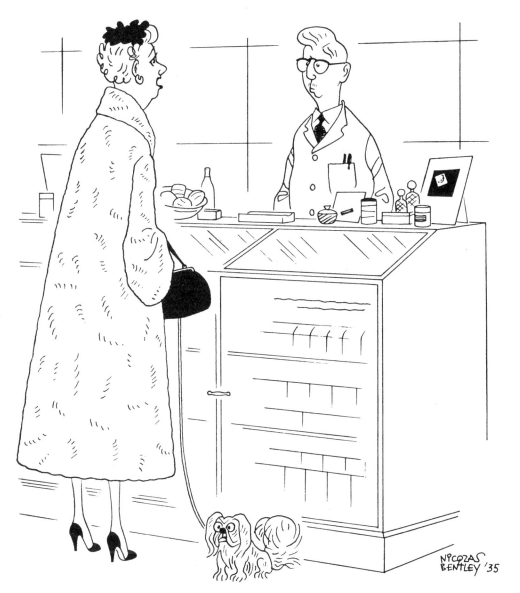

'*Have you anything for a poor doggie who just* cannot *sleep!*'
1935 (possibly unpublished).

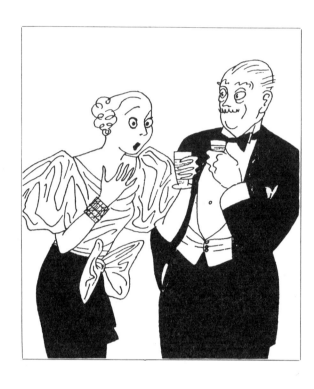

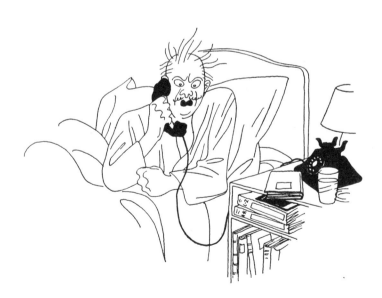

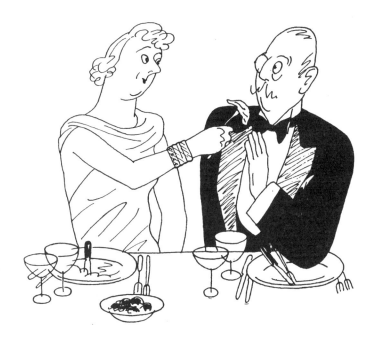

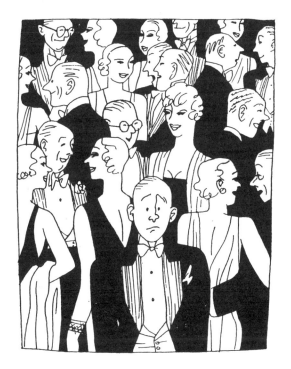

Four illustrations in almost lyrical
free line, for quotations from
Shakespeare, Burns, Thackeray
and Bacon in Bentley's anthology
*Ready Refusals, The White Liar's
Engagement Book,* 1935.

Disagreement in the French Chambre.

Foreigners, 1935.

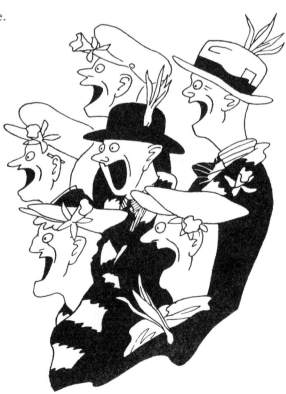

'Land of my Fathers!' (The Welsh).

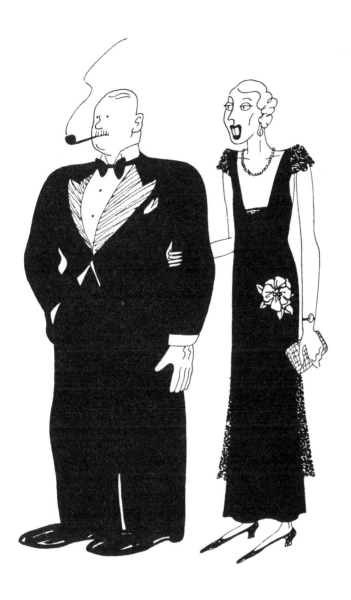

The Continental Idea of the English. *Foreigners*, 1935.

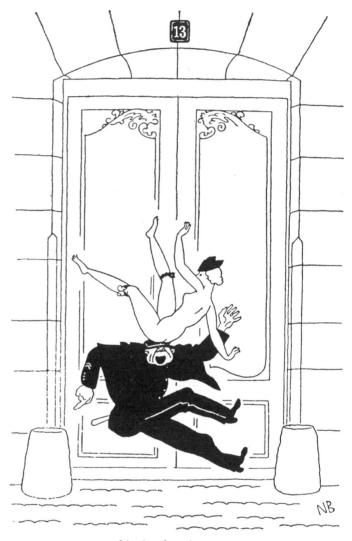

Dressed in her best hat and garters.

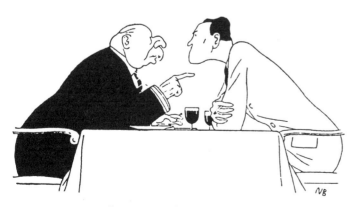

We became terribly Man to Man.

Black Henry.

Four drawings from
Parody Party, 1936.

Inciting the lower classes.

'Pythagoras my foot!'

'Oxford Dons are absent-minded, cultured, pernickety, eccentric and entirely out of touch with life.' Note the socks, *Muddling Through*, 1936.

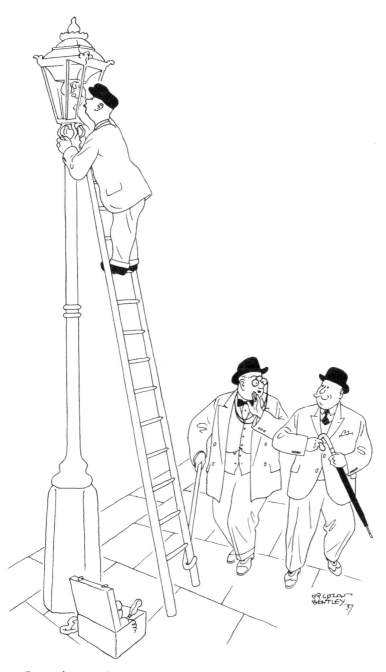

'*Get ready to run.*'

Night and Day, 15 July, 1937, and the same lamp-post.

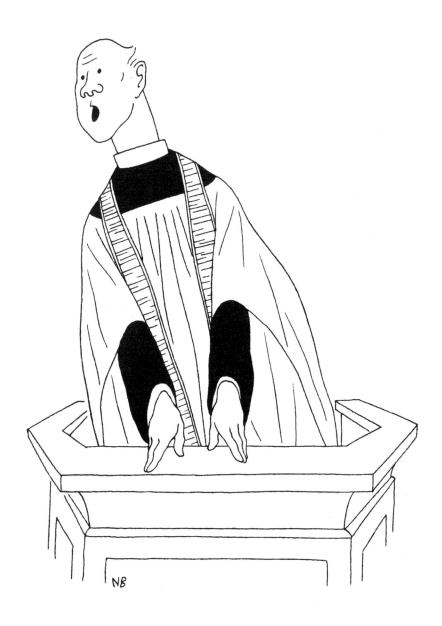

'*If any of you gathered here today have heard this one, stop me.*'
The Bystander, 1 Dec., 1937.

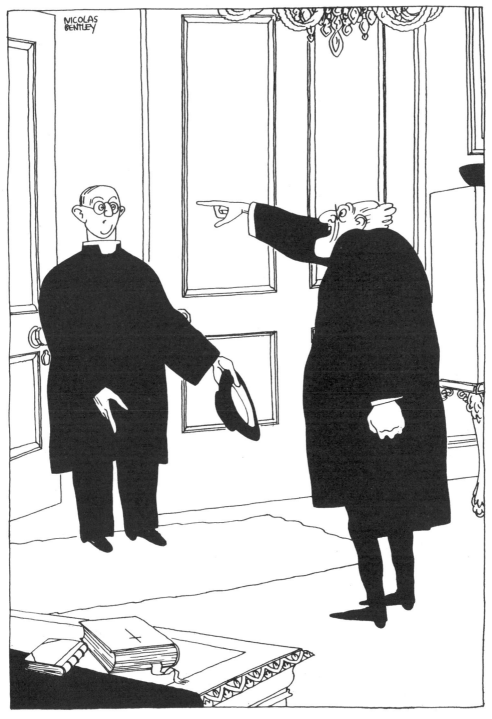

'Canon — you're fired!'

The Bystander, 22 May, 1934. Apart from the figures, note the beautiful detailing.

'I ran it up from a piece I got in the sales.' Men Only, 1937.

'*You've got a button undone!*'

Die? I thought I'd laugh!, 1936. Bentley collected catalogues of ecclesiastical clothing for accuracy.

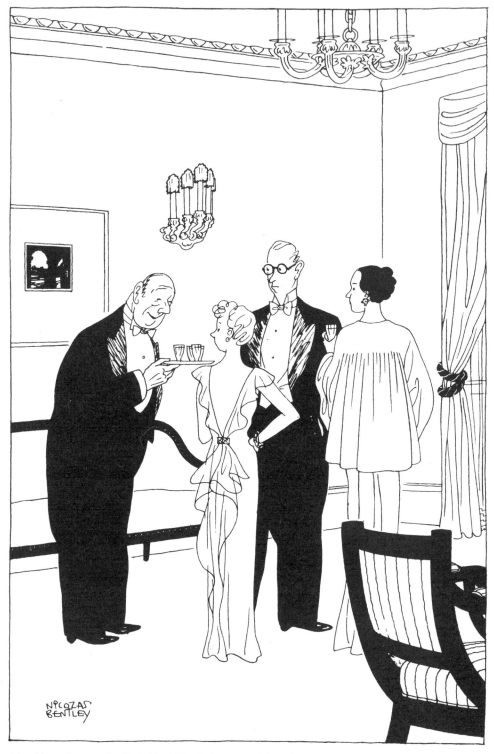

'And how about one for little Mrs What's-her-name!' Punch, 23 Oct., 1935. Perfect detailing of the ladies' gowns, as well as the furniture — and such a kind butler.

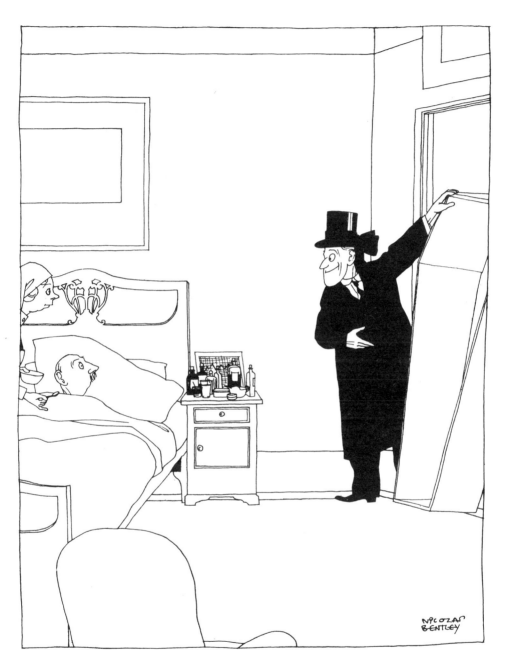

'How's this for size?'
Men Only, 1935.

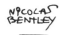

'Blimey, so I 'ave!' Men Only, 1936. The bill-sticker notices his mistake.

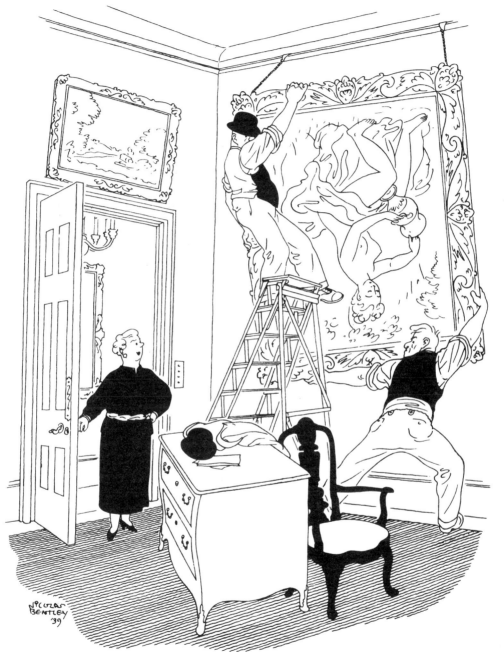

'I know, lady, I know!' The Bystander, 30 March, 1939. A variant on the joke opposite.

'*What'll you have? Same again?*'
Animal, Vegetable and South Kensington, 1940.

We also had a Bedlington called Butler . . .

The Time of my Life, 1937.

and a butler named Bedlington.

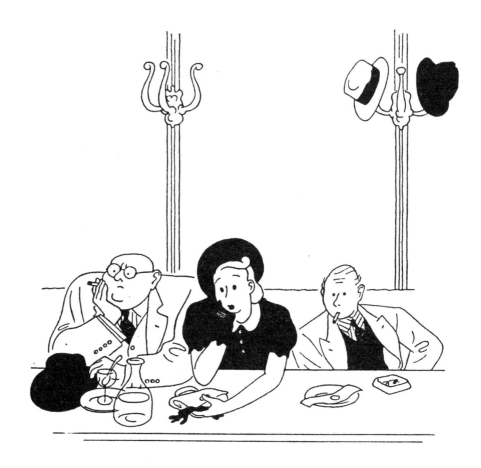

Pam's father was broke. But so were we . . .
The Time of my Life, 1937.

Bedlington on his way to a new situation in the Isle of Wight.
(Parkhurst Prison, probably).
The Time of my Life, 1937.

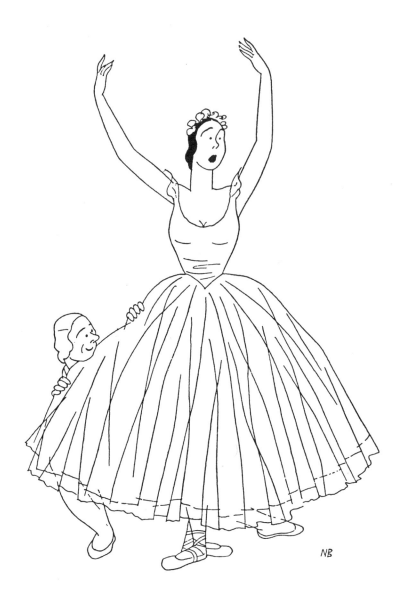

Irina Fallova and Michael Youpushoff in *Les Sylphides*.
Ballet-Hoo, 1937, written and illustrated by NB.

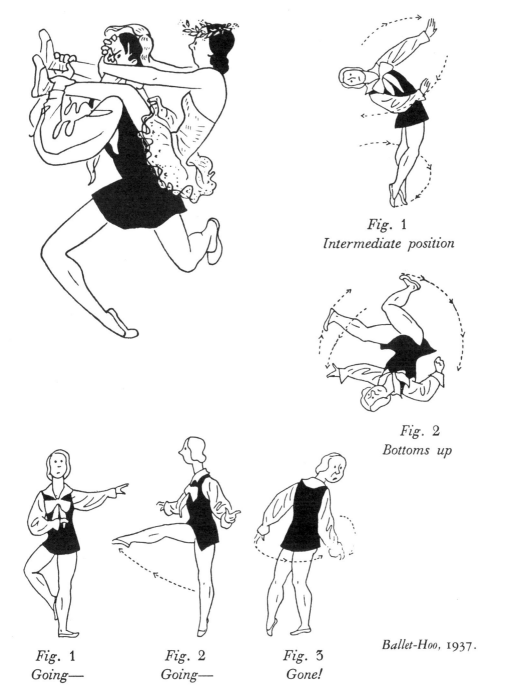

53

Fig. 1
Intermediate position

Fig. 2
Bottoms up

Fig. 1
Going—

Fig. 2
Going—

Fig. 3
Gone!

Ballet-Hoo, 1937.

He is so surprised he is practically tottering when he leaves the room.

More Than Somewhat, 1937, Damon Runyon's short stories of New York which were introduced to England by NB's father.

Many parties are very ticklish on the bottom of the feet, especially
if the matches are lit.

Furthermore, 1938, Runyon's second book.

The most powerful of Human Passions

Gentlewomen Aim to Please, by Jerrard Tickell, 1938, a distillation from Victorian Manuals of etiquette which gave Bentley scope for drawing costume.

Happy Christmas

This drawing, used as Bentley's Christmas card in the 60s, also
appeared with the caption 'Robert Browning at work'.

Religious doubts

Gentlewomen Aim to Please, 1938.

The Empress Maria Theresa
Had a poodle called Sneezer
Which severely bit
A Prussian from Tilsit.

Baseless Biography, 1939.
by E. C. Bentley.

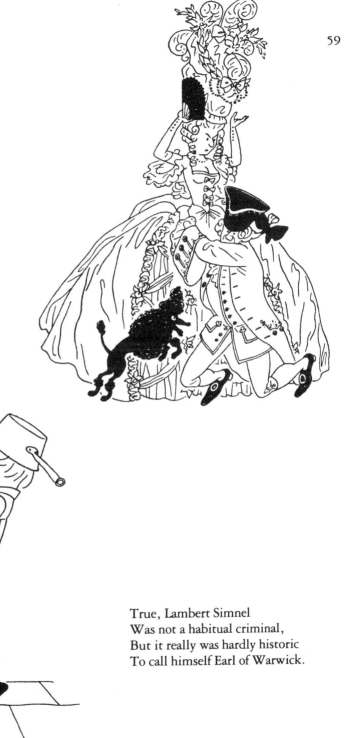

True, Lambert Simnel
Was not a habitual criminal,
But it really was hardly historic
To call himself Earl of Warwick.

'Don't bother to see ush out, Lady Shylvia.' The Bystander, 1936.

'And this, I'm afraid, is Mrs Glover.' The Bystander, 1938.
Again, beautiful detailing, and marvellous choice of costumes
and faces to make the point.

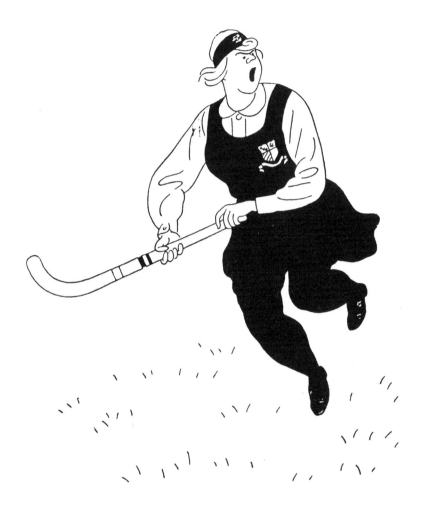

'*Pass, Gwyneth!*'
For many connoisseurs their favourite Bentley drawing.
In *Le Sport,* 1939, which Bentley wrote as well as illustrated,
he enjoyed himself at the expense of English attitudes to
and performances in the games we play.

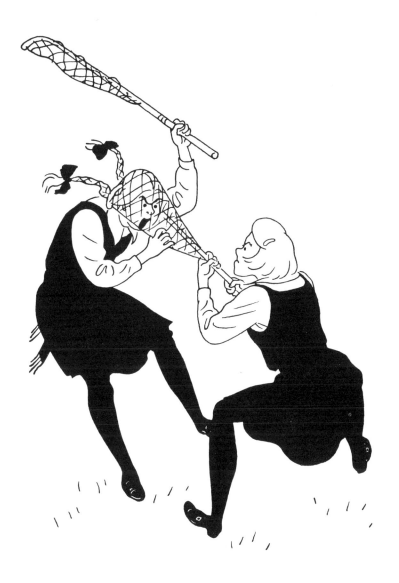

'*If you think just because you're a monitress — !*' *Le Sport.*

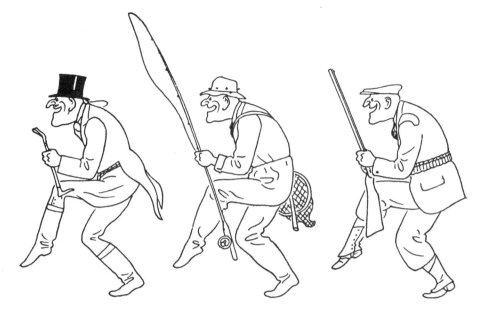

'That which distinguishes hunting, shooting and fishing from other forms of sport is the aim which is common to all three — namely assassination.'

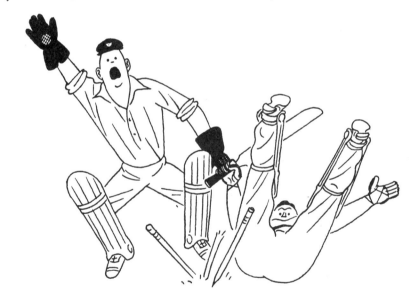

'*Howzat!*' 'I find it difficult to write dispassionately of cricket, not merely because I am an Englishman, but because Lord's is to me the most God-damned boring place in the whole of the British Isles.' *Le Sport,* 1939.

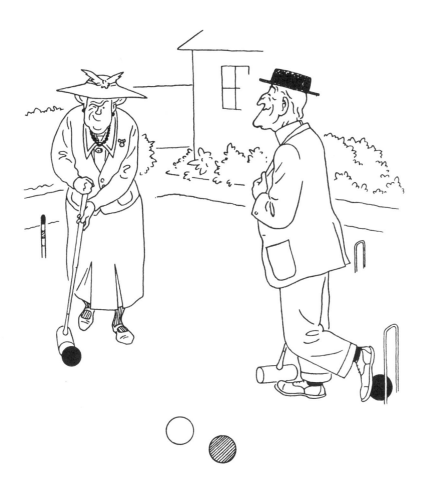

'Not since the death of my Aunt Carrie have I played croquet
seriously. But I have played it once or twice since on roller
skates in a muddy garden, which made it an infinitely more amusing game.'
Le Sport, 1939.

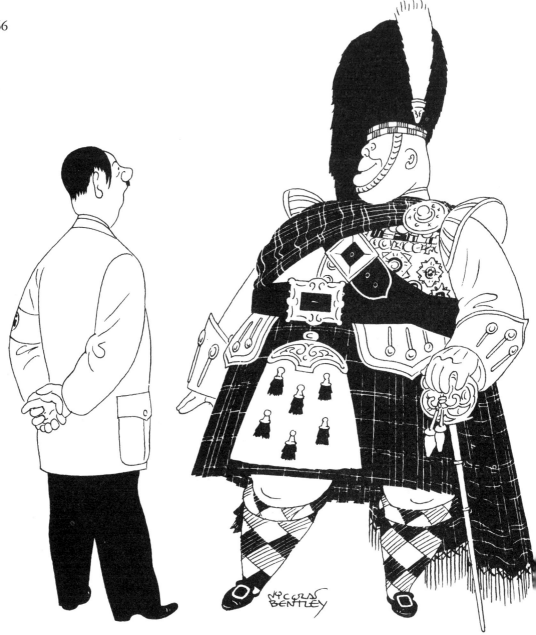

'It's for the Braemar Games — like it?'

The Bystander, 26 June, 1940; just about the exact day that most people in England expected invasion of the British Isles by Germany. Göring is here depicted showing off to Hitler.

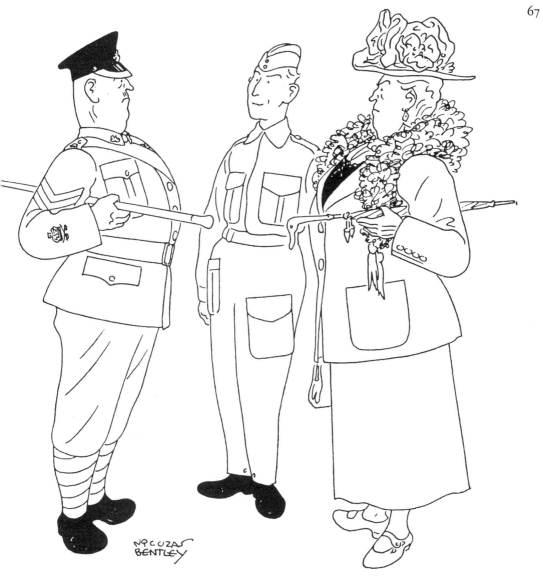

'Sergeant Bailey, this is my mother.'

Punch, 1940.

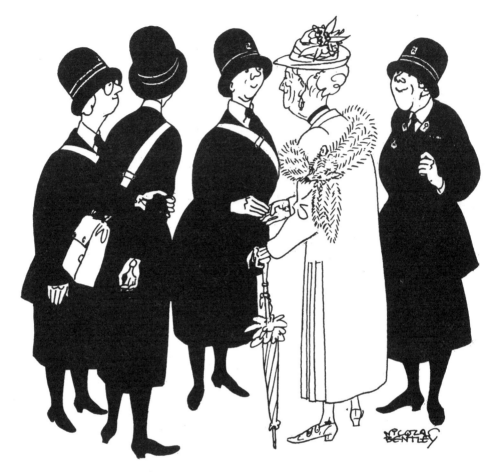

'and underneath this one we have Sister Maconochie.'
The ladies are in St John's Ambulance Brigade uniform, carrying
gas-masks.

Animal, Vegetable and South Kensington, 1940.

'Do that again and I'll drop you!'
Bentley knew about fires, he had been in them.
(possibly unpublished.)

'Ah — also an Ovaltiny, I see!'

The makers of Ovaltine, a harmless bed-time drink made with hot milk, had created a 'club' for children with a badge and pass-words. *Lilliput,* June, 1940.

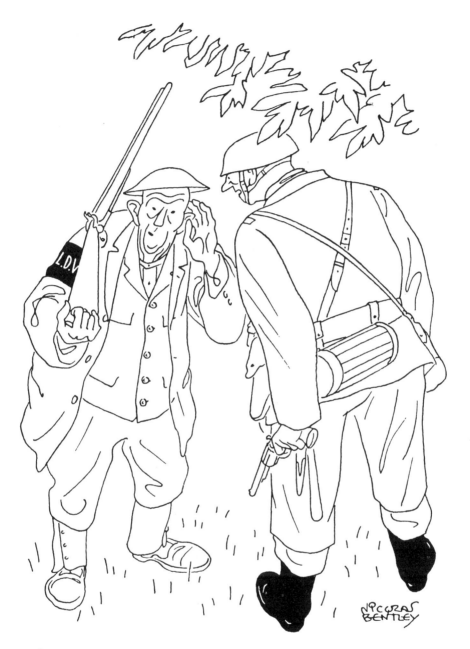

'Eh?' *Animal, Vegetable and South Kensington,* 1940.

The elderly yokel wearing the sleeve-badge of the 'Local Defence
Volunteers' (re-named by Churchill in 1940 'Home Guard') faces a
German paratrooper. Pont drew the same joke: a housewife in her garden
saying to a parachutist 'How *dare* you come in here' — but curiously
Punch decided it would be against the national interest at that time
and would not print it. See *Pont,* by Bernard Hollowood, Collins, 1969,
p. 183.

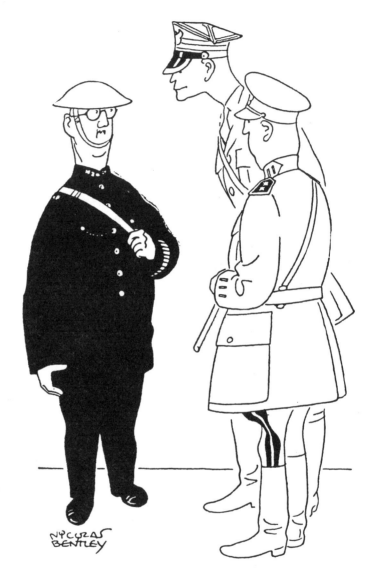

'*Prosza Pana, która iest najblizsza droga na Tottenham Court Road?*'
'*Sir, can you tell us the nearest way to Tottenham Court Road?*'
Lilliput, November, 1940. At this time London was full of
unfamiliar languages and uniforms. A suspicious War Reserve
policeman faces two Polish officers.

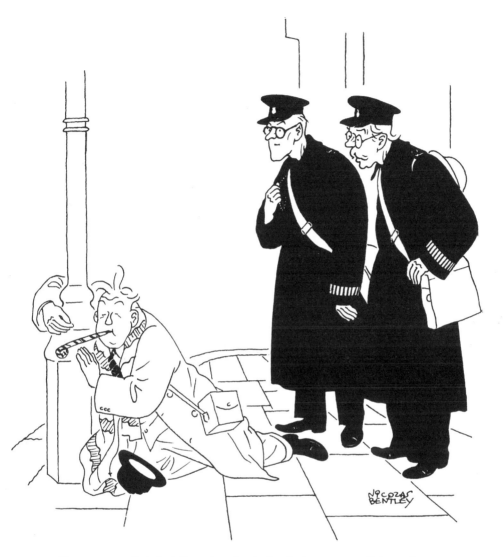

'How say you. Brierley? Excessive stimulation due to an over-sufficiency of alcohol?' The Bystander, 19 June, 1940.

Two schoolmasters (or Oxford dons?) enrolled as temporary London War Reserve policemen (as was the present author), carrying tin hats and gas masks, are nicely identified both by their faces and their language.

Into the midst of the ocean went Silvanus. Into the wind and the storm. Into the heart of the great waves that pitched the ship this way and that as if she were no more than a feather; that lifted her high and dragged her

Silvanus felt most awfully glad to have the goat to look after and the goat was glad too, and gave him happy little butts with its hard head all the way back to the farm. He built a sort of shed for the goat and milked it every morning and every evening. He called it Gerty, and they became great friends.

Two pages in b. & w. (reduced) in *Silvanus Goes to Sea.*
1943, which was mostly illustrated in colour.

Dorinda and Dinah pack their clothes into an oak tree before drinking the potion that turns them into kangaroos. Below, they eventually remember how to turn themselves back again, and find their clothes rather crumpled and damp. *The Wind on the Moon,* a story for children by Eric Linklater, 1944, the only real novel ever illustrated by Bentley.

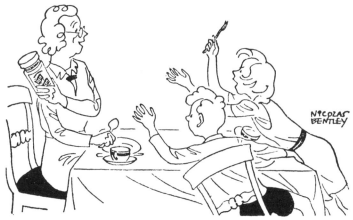

Miss Prunella Prissom who is one of nature's

aunties, has achieved miracles of table discipline with
her two evacuees. But, praised in this connection,
she twitters: "Fiddlesticks! I simply give 'em Pan
Yan when they behave and when they don't, I don't."
Oh, unerring judgment of womankind!

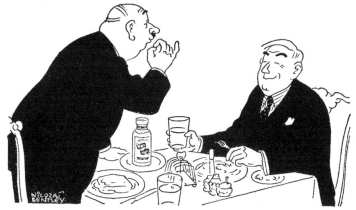

M. Gaston Bonvivant, lately

of Paris (France) confesses himself a total convert to
the excellence of our English cuisine. Particularly
is his heart rejoiced by "*le merveilleux lapin des
Galles*" (welsh rarebit to us). This, and a garnish-
ment of what he calls *Pon Yon*, almost reconciles
him to the loss of *Cêpes à la Bordelaise*.

Drawings for two
Pan Yan Pickles
advertisements, 1940s.

1 Choke-shrink . . . Jim doesn't know whether to choke or crash! His shirt fitted when new, but now it has shrunk noose-tight!

2 Hope-shrink . . . George isn't hot under the collar! He bought his shirt oversize to allow for shrinkage, and he's hoping to shrink it to fit.

3 Won't-shrink . . . Buy your shirts, overalls, pyjamas the right size . . . if the label says "Sanforized" they won't shrink out of fit.

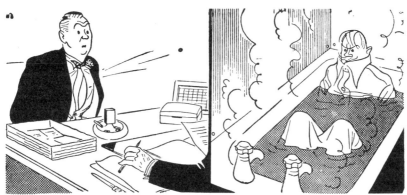

1 Choke-shrink . . . Neil's interview went fine until that button flew off. His shirt was a good fit when new. Now it's choking him with embarrassment!

2 Hope-shrink... John hasn't slipped up on the soap. He bought his shirt oversize to allow for shrinkage. Now he's hoping to shrink it to fit.

Shirts with this label won't shrink out of fit

Drawings for a seies of advertisements for Sanforized non-shrink shirts, 1947-8.

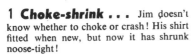

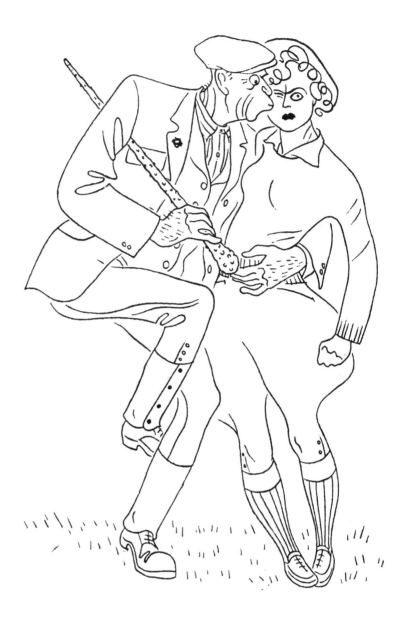

'Sums ranging from £5 for a Land Girl's kiss to £700 for a bullock have been raised at country sales for the Red Cross Agriculture Fund . . . ' *This England 1940-1946.*

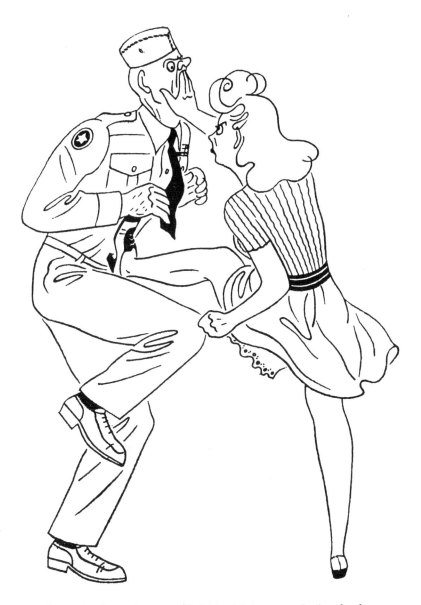

'What attitude on the part of British girls is most calculated to keep
Americans at their best level of social behaviour? — from Army
Bureau of Current Affairs discussion Notes. *This England 1940-1946*
was compiled from competitions in the *New Statesman* to find
oddities in the English press.

*'Mark you, I have never given the slightest encouragement
to either Bulganin or Khruschev.'*

How Can You Bear To Be Human? 1957.

Time & Tide, 2 **May**, 1953.

'Dug up? You're always wantin' to be dug up. Why can't you let the child enjoy himself?' *Time & Tide*, 15 August, 1953.

'*Hey! She was only meant to kick off——*'

Three variations on a theme without words. Left, above,
Time & Tide, 1952. Left, below, *Punch,* 1953. On this page, *Punch,*
1953.

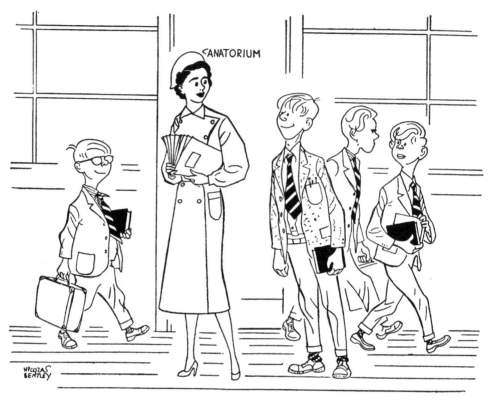

'*Are you the new nurse?—'cause if so I'm feeling far from well.*'

Time & Tide, 13 June, 1953.

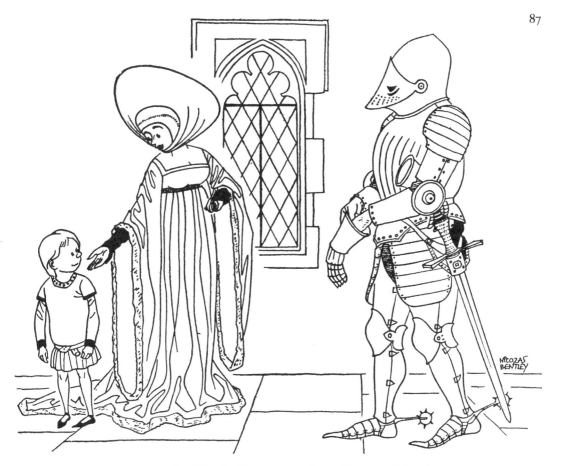

'Here's Daddy, darling, run and get the screwdriver.'

Time & Tide, 19 Sept., 1953.

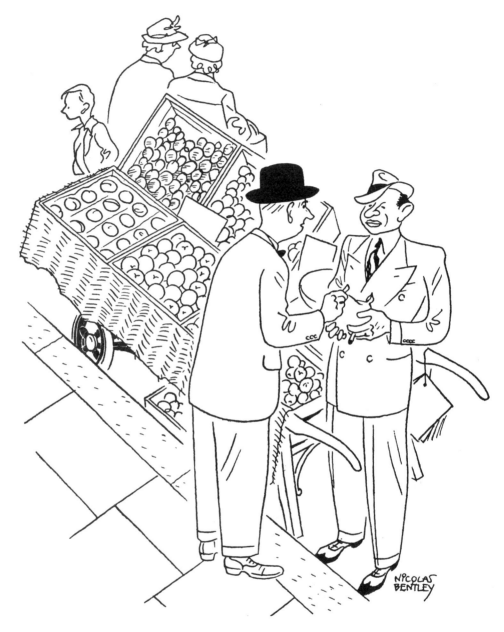

'And would you mind also telling me who your tailor is?'

How Can You Bear To Be Human? 1957. London barrow-boys were always sharp dressers.

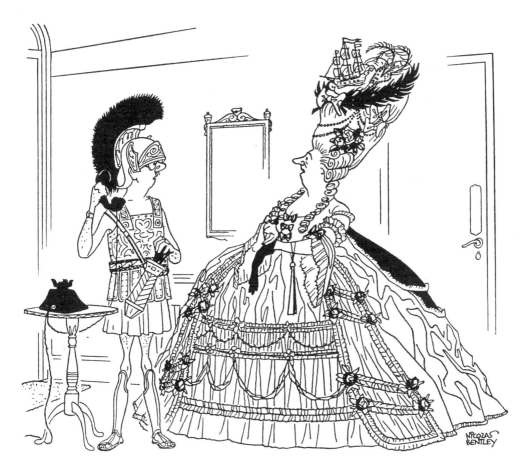

'She says they've cried off the Chelsea Arts, will we meet them at the Dorchester instead.'

How Can You Bear To Be Human? 1957.
The Chelsea Arts Ball was an annual fancy-dress riot for artists.

The end-papers of *How Can You Bear To Be Human?*

were a compilation from published and unpublished work.

92

Another double-spread 'anthology' from *How Can You Bear To Be Human?*

Most people in England could put a name to every face here from their own friends and relatives.

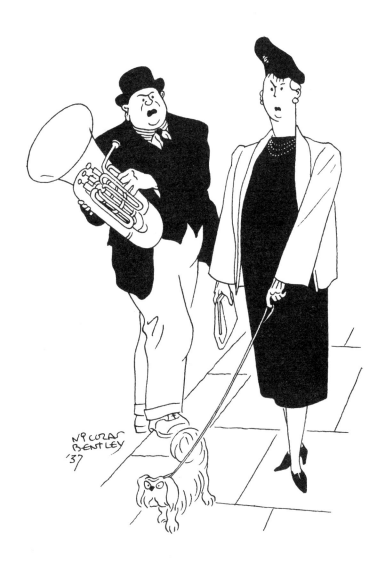

'O.K. P'raps you'd like to show us 'ow it goes yourself?'
Lilliput, Nov., 1938. Outraged dignity (including the Peke)
appealed to Bentley, as did the little dramas on London streets
which he often drew. Three more examples follow.

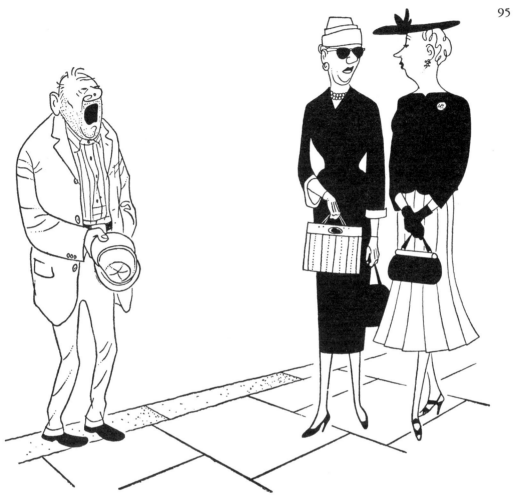

'Are you going to Glyndbourne this year?' Punch, 18 July, 1956.

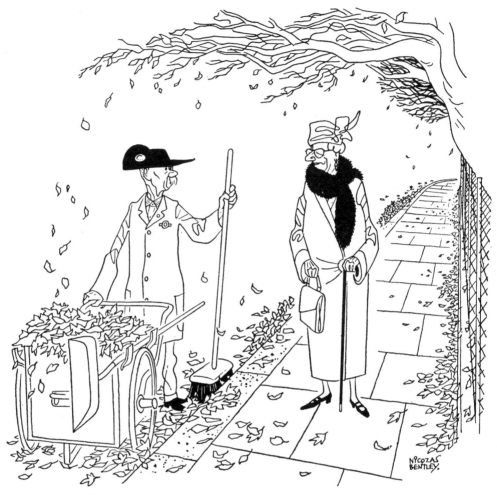

'*I do so love it when the autumn leaves begin to fall, don't you?*'

How Can You Bear To Be Human? 1957.

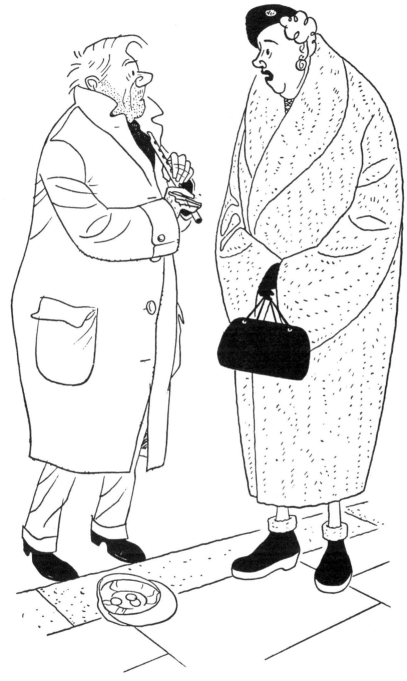

'And I honestly wouldn't spend another winter in England, if I were you.'

How Can You Bear To Be Human? 1957.

This and the next three pages show illustrations from *The Girl Watcher's Guide*, 1956, by Don Sauers. It is stated to be suitable for both old (left) and others (right) 'who watch girls simply because it makes them feel *good*'.

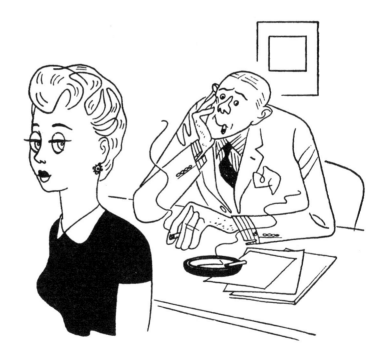

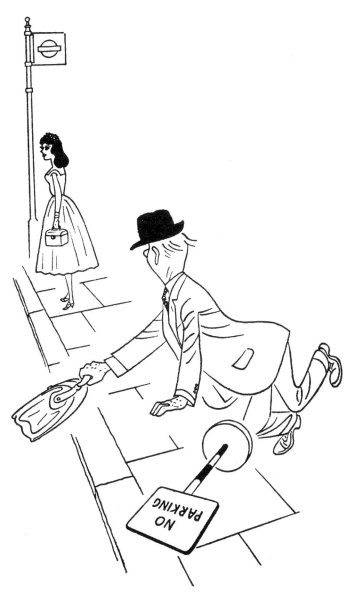

Beware of diversions

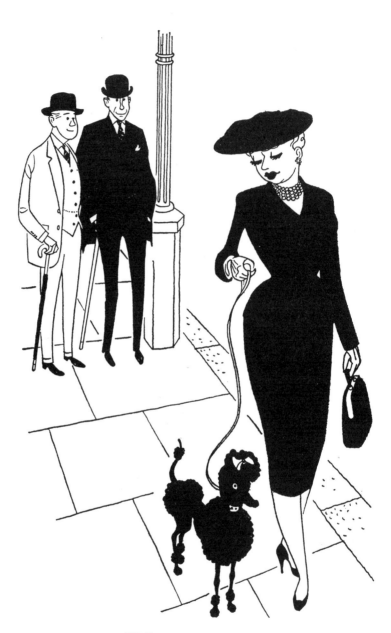

Well-preserved Fortyplus

Quick-stepping Hatboxtoter

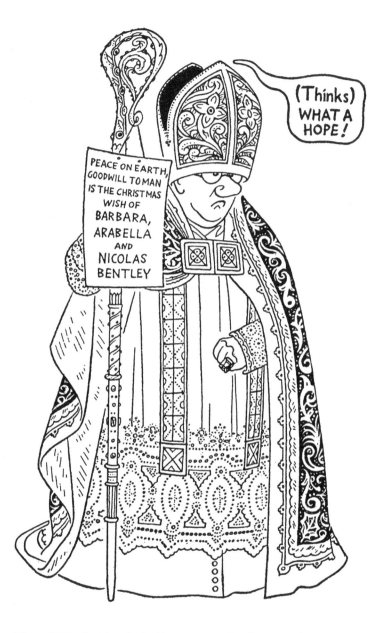

Two of Nicolas Bentley's Christmas cards: above, 1960s; right,
1972. See also p. 57.

'WELL, IF IT'S **NOT** THE RIGHT ONE, I'M GOING TO HAVE
A FEW WORDS TO SAY TO PATRICK MOORE.'

WITH ALL GOOD WISHES FOR CHRISTMAS
FROM
BARBARA AND NICOLAS BENTLEY

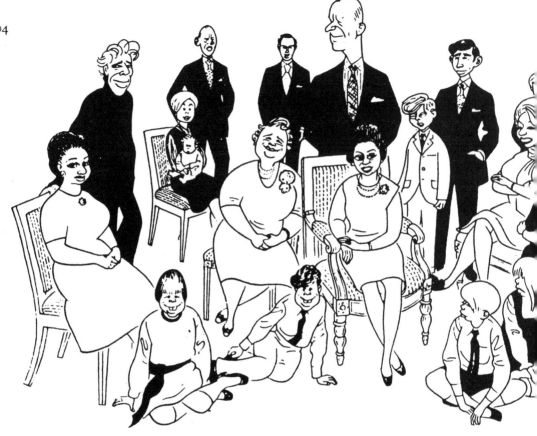

The Royal Family in 1972: Bentley's view was not the same as, for example, Cecil Beaton's. 'Auberon Waugh's Diary' in *Private Eye*, 17 Nov., 1972.

Another drawing for 'Auberon Waugh's Diary', *Private Eye*,
9 Oct., 1973, depicting, from l. to r., Lord 'Grey' Gowrie,
Anthony Barber, Edward Heath, the 'radiant, sublime beauty' of
Miss Gillian Widdicombe, the *Financial Times's* brilliant music
critic, Lord Douglas-Home, and Robert Carr. Behind, in bow tie,
Peter Walker.

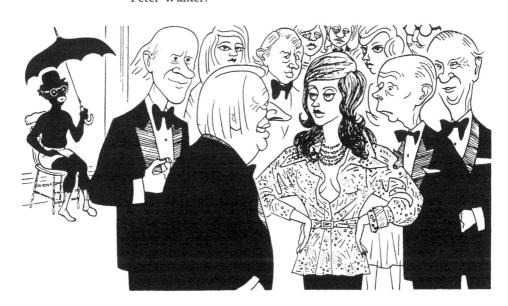

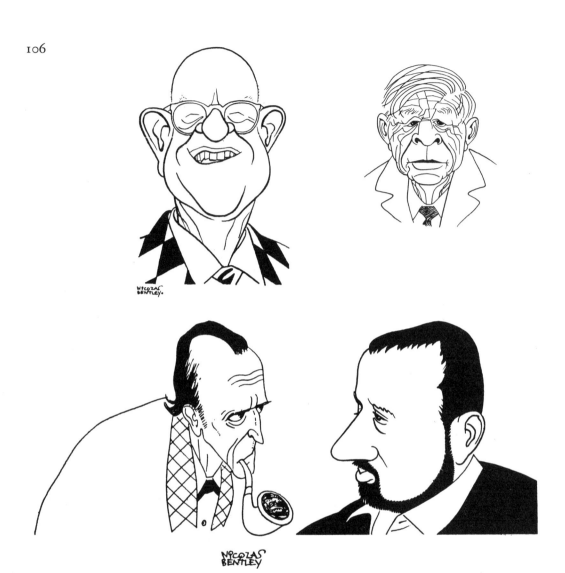

P. G. Wodehouse W. H. Auden

Sherlock Holmes *Sunday Telegraph*, 1960s. John Fowles

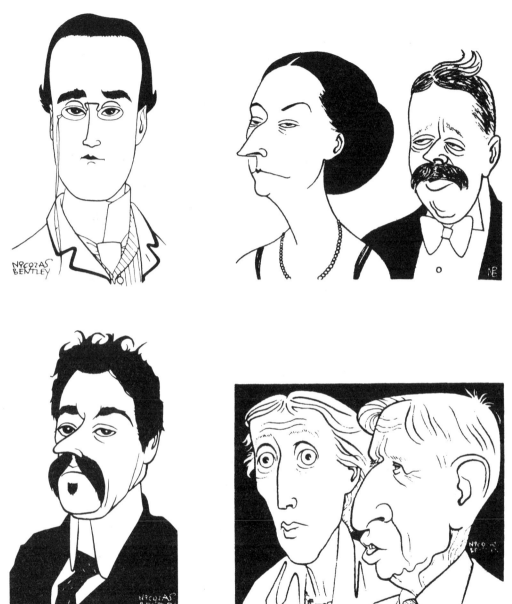

F. W. Rolfe, Moura Budberg (?), Arnold Bennett, J. M. Synge,
Virginia and Leonard Woolf, from the *Sunday Telegraph*, 1960s.

'I simply haven't dared to tell her the Russians have launched a new Sputnik.' 16 May, 1958.

'Listen, Dad — if I pass my eleven plus can I have a bash at being a sex kitten?' 29 Jan., 1959.

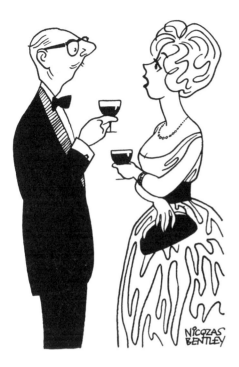

'Tell me, Mr Dinwiddy, how does a Scottish draper magnate deal a counter-blow?' 25 June, 1959.

'I shudder to think, Monica, what I shall be learning if they go on raising the school leaving age.' 12 Dec., 1959.

'How do I indicate that to a certain extent my sympathies are divided?' 15 March, 1962.

'If we really are going to save £90 million by cutting the atomic programme, I don't feel I'm in a position to insist' (Unpublished).